SIMPLY

Calligraphy

SIMPLY

Calligraphy

A BEGINNER'S GUIDE TO ELEGANT LETTERING

JUDY DETRICK

WATSON-GUPTILL
PUBLICATIONS
Berkeley

Published in the United States by Watson-Guptill Publications, an imprint
of the Crown Publishing Group, a division of Penguin Random House LLC,
New York.
www.crownpublishing.com
www.watsonguptill.com

WATSON-GUPTILL is a registered trademark, and the WG and Horse
designs are registered trademarks of Penguin Random House LLC.

Library of Congress Cataloging-in-Publication Data
Detrick, Judy, author.
 Simply calligraphy : a beginner's guide to elegant lettering / Judy Detrick.
 pages cm
 Includes bibliographical references and index.
 1. Writing, Italic—Handbooks, manuals, etc. 2. Calligraphy—Technique. I.
Title.
 Z43.D47 2016
 745.6'1—dc23

 2015031938

Trade Paperback ISBN: 978-1-60774-856-4
eBook ISBN: 978-1-60774-857-1

Printed in China

Design by Tatiana Pavlova

10 9 8 7 6 5 4 3 2

First Edition

*This book is dedicated to Arrighi,
my first calligraphy teacher.*

CONTENTS

∼ INTRODUCTION ∼

Although digital technology today seems to have rendered handwriting obsolete, what is not obsolete is the distinct pleasure derived from receiving a beautifully penned envelope and opening a handsome handwritten letter. You may have admired a beautiful piece of calligraphy and wondered how to do it yourself. With a little effort, you can learn to craft lovely letters for every occasion.

This book will provide you with the first steps toward developing a calligraphic hand that is unique to you, attractive, and easy to read. The sample alphabet in these pages will help you learn the proper form of letters as they were created long ago, during the Italian Renaissance. Called italic, this is the hand most commonly seen on wedding invitations, hand-lettered menus, and other artful presentations. I will lead you through a series of exercises that will help you acquire a handsome italic hand, and I'll suggest fun projects that will give you practice in a practical way. I'll encourage you to try a variety of pens, inks, and papers to find the right ones for you. You will also receive guidance with layout and design, advice on addressing envelopes, and ideas for flourishes and other embellishments.

Of course, results are not instantaneous, and your handwriting doesn't come with a spell checker or Delete key, but the more you practice, the faster you will improve! So let's get started.

1.

~ TOOLS AND MATERIALS ~

As with any effort, the right tools make all the difference.

PENS

Any ordinary pen can be used to make beautiful letters, but the beauty of italic calligraphy is accomplished by using a broad-edge pen. The ribbonlike appearance of the italic alphabet, with its thick areas and thin areas, is created with a broad-edge pen held at a fairly constant angle. Notice that the end of the pen nib is squared off, much like the end of a screwdriver or a chisel. You can see why it's referred to as a broad-edge pen, or sometimes as a square-cut or chisel-edge pen—these terms are synonymous.

Broad-edge pens come in a variety of sizes and materials. You can find them made from metal, bamboo, feather, or felt. Some are easier to use than others, and some produce results far superior to others. A broad-edge fountain pen is a good beginning tool. The fountain pen has the advantage of always being ready to write, and the ink flows reliably. A good choice to begin with is a Pilot Parallel Pen. It comes in several sizes, but the exercises in this book will use the 1.5 mm nib, so I suggest that you start there. After you're familiar with that size you can get larger or smaller pens. It's definitely to your advantage to have several sizes.

INK

The pen comes with ink cartridges, but rather than continually replacing cartridges, seasoned calligraphers refill their cartridges with ink of their own choosing. The cartridges can be refilled easily with a pipette or an injector. Try several kinds of ink to find the one(s) you like to work with. I recommend starting with Noodler's ink—it comes in a wide range of colors, making your writing that much more fun. You should avoid waterproof inks, though, as they may ruin your fountain pen if allowed to dry inside.

PAPER

The right paper is just as important as the pen you use. Your calligraphy will be enhanced when presented on quality paper, with its subdued color and notable tactile qualities, and writing on quality paper is a pleasure in itself. Ordinary college ruled notebook paper, however, will provide you with an inexpensive way to practice. It's lined with just the right amount of space between the lines for writing with the 1.5 mm pen. After you've had some practice, and when you feel ready, search out the best papers for your projects. An art store, stationery store, or calligraphy supply vendor will have papers you can try to see which work best for you. All kinds of paper, from stationery to printmaking and watercolor papers, are suitable for calligraphy. See Further Studies and Resources, page 82, for sources for pens, inks, and papers.

2.

~ **GETTING STARTED** ~

It's a good idea to warm up each time you sit down to do calligraphy. To become acquainted with your broad-edge pen, begin by making loops, spirals, zigzags, ovals, or whatever kind of marks you like. Get used to using a light touch. Bearing down on the nib will do little for the appearance of your writing and will easily tire your hand. The key is to hold the pen lightly and at a constant 30-degree angle. Finding the 30-degree angle is easy.

The illustration shows the face of a clock. When the right corner of your nib points at 2 o'clock and the left corner at 8 o'clock, that is a 30-degree angle. Practice holding your pen at that angle until it feels natural. (Note: The pen is held at a 30-degree angle regardless of whether you are right- or left-handed. Left-handers may have to turn their paper to get in the proper position.) You may need to remind yourself about the 30-degree pen angle as you go along, but it will become second nature to you before you know it. By always holding your pen in that position, you will see thick and thin parts of your doodles emerge reliably, and you are well on your way to learning calligraphy.

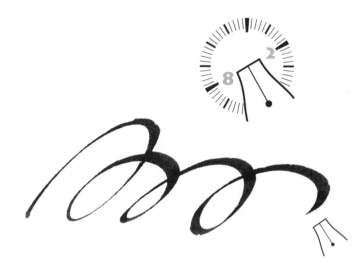

Slanted Downstrokes

Now you're ready for your first exercise. On a sheet of regular lined paper, make slanted downstrokes of varying heights and depths to mimic the varying heights and depths of the letters of the alphabet. For example, the letters *d*, *b*, *f*, *h*, *k*, and *l* have ascenders—strokes that rise above the mean line—and *g*, *j*, *p*, *q*, and *y* have descenders, strokes that fall below the base line. All the rest of the letters are contained in the middle space called the body.

There are three important things to practice in this exercise:

1. Make sure you maintain a constant 30-degree pen angle.

2. Make sure all your strokes slant in the same direction. These strokes can assume the same slant as your ordinary handwriting, which is something you do already without giving it much thought. It's OK if you don't have much of a slant. The important thing is to keep your slant consistent; that is, make the downstrokes parallel to one another.

3. Make sure that the space between downstrokes is the same. The italic alphabet is composed of letters whose sides are straight and equidistant. Memorizing this distance can help you greatly in achieving a beautiful, rhythmic italic hand.

That's a lot to practice in one sitting, so repeat this exercise regularly until you can do it with ease and a natural rhythm.

ascenders

body

descenders

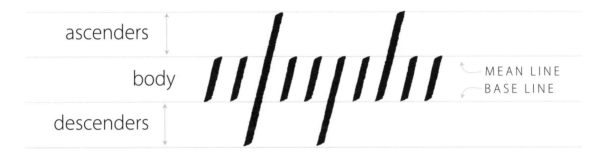

MEAN LINE
BASE LINE

3.

~ SMALL LETTERS ~

The Basic Shapes

The next exercise will familiarize you with the fundamental shapes of italic small letters (also known as minuscules). Pick up an ordinary pencil or ballpoint pen. Writing these letters with a tool you are already familiar with allows you to concentrate fully on the letterforms. Copy the letters as shown, beginning each from top to bottom, left to right. Use the full height of each line of your notebook paper as shown. It is essential that you learn and memorize the shapes of these letters now before taking up the broad-edge pen. This skeletal version of italic can also be used as the basis of a pleasing form of everyday handwriting.

Refer to this illustration frequently as you go along to make sure you are making the right shapes. Compare your letters with the example, and make any corrections necessary. A close look at these letters reveals straight sides that slant in the same direction. They take on the look of letters because of what we add at the tops and bottoms of these straight sides. When reading, our eyes skim mainly the tops of letters and tend to skip their bottoms, but both are important in calligraphy.

abcdefghij

klmnopqr

stuvwxyz

Proportions

Once you have the italic shapes firmly in mind, you can begin writing them with your pen. Before you start, check that you will be writing them at the right proportion for the size of your pen. Traditionally, the size of the body of the small italic letters equals five widths of the pen. If you know how wide the tip of your pen is, you can multiply by five: that is your body height space. If you'd rather not have to multiply anything, an alternative is to make a pen scale.

Hold the pen flat (with no angle), and make five short strokes with corners touching, as shown in the illustration. It is then but a matter of measuring the distance between the outer edges of this stair-step pattern and marking it on your paper to create guidelines for your work. The length of ascenders and descenders is largely a matter of personal preference; it can range anywhere from two to five pen widths, but on occasion can go even higher than five pen widths. For now, in the interest of simplicity, make them five pen widths.

Since you won't always be writing on notebook paper with a 1.5 mm pen, knowing this method makes it possible for you to figure out the amount of space to allow when creating guidelines, no matter what size nib you're using or what paper you've chosen. Keep practicing on notebook paper for now, because the area between the lines conveniently accommodates five widths of a 1.5 mm pen.

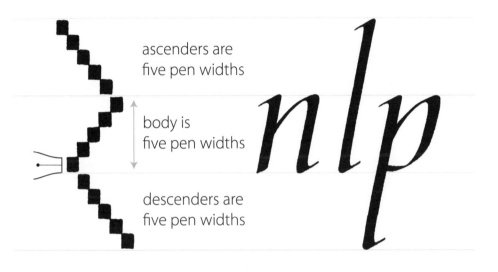

ascenders are
five pen widths

body is
five pen widths

descenders are
five pen widths

nlp

The Easiest Letters

The skeletal forms you practiced with a ballpoint pen are the foundation of italic calligraphy. The models that follow show how they look when made with a broad-edge pen. They are made large so you can see the details more clearly, but you will be making identical letters on a smaller scale on notebook paper with your fountain pen. Note that the model letters fill the entire space between the lines, and the ascenders and descenders fill their own space as well. Yours should do the same.

The arrows show the direction and the order of the strokes. Since the sequence for each letter is mainly top to bottom, left to right, most of the strokes will be "pulled" toward you. Look at the models and note where the strokes are the thinnest. That part of the stroke indicates where to start a stroke and where to stop a stroke. If you come to a thin part but haven't completed the letter, lift the pen and come back to the thin place from the opposite direction. The reason for this is that the pen may not glide easily past that thin line without resistance and splatters, especially when using a traditional dip pen as opposed to a fountain pen. For now, you will write only the small letters. Take your time, and write slowly and deliberately. The capitals and numerals will follow.

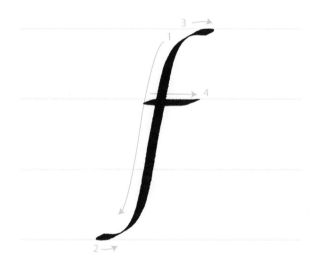

The models begin with the easiest letters first: *i, j, l, t,* and *f.* Take note of the stroke sequence and direction. The letters *i, j,* and *l* begin with a short entrance stroke called a serif, moving left to right. At the bottom of *i, l,* and *t* is an exit serif moving left to right out of the letter. Visualizing an ordinary check mark will give you an idea about the kind of movement you'll make and the look you'll achieve when making these serifs. You will find entrance and exit serifs on many of the letters. Try to make them as thin and short as you can. If you find it difficult to incorporate the serifs into your writing, it is quite all right to omit them for now. Add them in when you are confident you are making the letters correctly.

To create the dots over the *i* and *j,* make a short stroke moving from right to left and slightly downhill. More detailed options will be covered when we get to punctuation (page 30).

The *f* has no serif; rather, it has a gentle, shallow curve at the top and at the bottom. Notice that the *t* has a very short ascender, not as tall as the other letters with ascenders. This was implemented many hundreds of years ago to differentiate it from a *c.* The crossbar on *f* and *t* is placed at the top of the mean line. When you have an instance of two *t*'s or *f*'s they may share the same crossbar. Remember to make your slanted strokes the same distance apart.

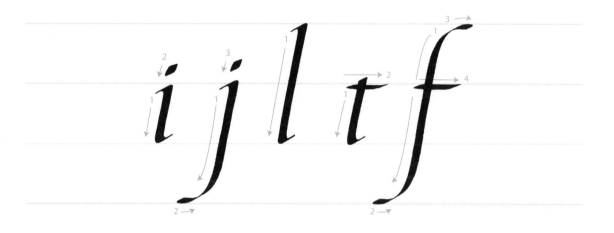

Arches

The next group of letters are *h*, *k*, *m*, *n*, and *r*. These letters have rather pointy arches that begin to branch from the middle of the body height of the first stroke. Think of the *r* as an *n* that stops in mid-arch. The *k* also branches in the same place; the loop meets at that branching point, and the leg kicks out from there. Again, the goal is to make your strokes slant the same and appear to be the same distance apart.

Closely related to this group are the *u* and *y*. If you turn the book upside down, you will notice that they have the same arch as the *n*, only inverted. I call these bottom arches. Aim the end of your arches toward the middle of the body of what will be the last stroke.

h k m n r u y

Curves

The next group of letters are *o*, *c*, and *e*. At first glance it may not be apparent that the sides of *o*, *c*, and *e* are straight, slanted, and parallel to one another, just like the preceding letters. The curves are at the top and bottom only. Do not make these letters round. Some find it helpful to think of a *u* shape when making these letters. That helps to keep the sides straight and parallel to one another. These letters are usually made in two strokes, both starting at the top. For the *o*, the first stroke on the left goes down (straight) and around to the right, and the second, a mirror image, goes around to the right, then down (straight); they meet toward the bottom right. The *c* and *e* resemble an *o* on the first stroke, but the bottom is a bit wider. The top of the *c* is a separate short horizontal stroke. The loop on the *e* is made with a separate stroke starting at the top. Do not let these letters become wider than the *n*. Included in this group is the ampersand, a symbol that stands for *et,* the Latin word for "and." It is easy to see the *e* and *t* that make up this version. There are many varieties of the ampersand; this is one of the simplest.

The letter *s* is included here because it uses the same top as the *c,* and when that top is inverted, it provides the bottom stroke. Begin *s* with the angled stroke first. It curves a bit at the beginning and the end of the stroke, but is straight in the middle. The top and bottom strokes are added last; they are short horizontal lines that join the slight curves at the beginning and end of the *s*-shaped curve.

o c e g s

The "a" Group

The *a*, *d*, *g*, and *q* all share the same characteristic body shape. Their sides are straight and parallel to one another, and the tops are horizontal. Without some softening of this boxy shape, however, the letters would have a stiff, awkward appearance. So the upper left corner is a bit rounded off, and the bottom left corner is angled toward the middle of the body on the right side. As with the "o" group, you may find it helpful to think of a *u* shape when making these letters. The top horizontal stroke can be made first or may be added last.

Closely related to these four letters are the *b* and *p*. Again, turn your book upside down and you will see they have the same characteristic shape as the "a" group. Their horizontal stroke is at the bottom rather than the top, and they begin branching halfway up the body of the letter, just like the *n*. You may find it helpful to think of an *n* shape when making these letters.

a d g q b p

Straight Slants

The next group of letters—*v*, *w*, *x*, and *z*—are composed of straight, slanted strokes, each made separately beginning at the top. Make the tops the same width apart as the *n*. The *z* begins and ends with a horizontal stroke connected by a thin diagonal stroke. This diagonal stroke going from right to left is made naturally by the pen held at the 30-degree angle. Compare that to the thick diagonal stroke of *x*, which is made going from left to right by the pen held at 30 degrees. These strokes represent the extremes of the width of strokes possible in the italic hand.

$V W X Z$

Punctuation

Punctuation is included as part of this example. Periods take on a diamond shape as you pull the stroke down and diagonally toward the right. You can place periods at the base line where you are used to seeing them or, for an interesting variation, place them at the midpoint of the body height. Commas are periods with a short tail made by pulling the left corner of the nib down and to the left. Notice the position of the quotation marks: just a bit above the mean line or the height of your capitals.

If you create punctuation marks by pulling the stroke down and to the left, you will get another look altogether. Such marks are thinner, more subtle strokes and interfere less with the overall texture of the writing. This is also an option for dotting the *i* and *j*. Try them all!

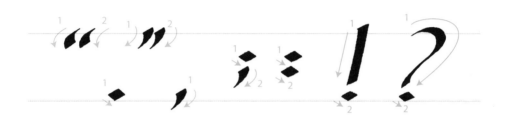

Variations

Some alternate forms of small letters are shown next, as well as letter pairs that can sometimes be joined in interesting ways. Shown is a suggested way of handling two ascender strokes together, such as occurs with *fl, ff,* or *ll.* Borrowed from the *f* is an alternate way of writing the tops and bottoms of other letters with ascenders and descenders. This is the basis for more exuberant flourishes; you should master it before attempting anything grander.

Two alternate forms of *g* are shown. The first shows a simple closed loop to the descender. The next *g* appears a bit baffling to construct but can be accomplished by carefully following the steps as shown. This *g* is well worth the effort to learn. Begin by making a small letter *o.* Notice that it is shorter than a regular letter *o;* it does not go all the way down to the base line. Next, make the large *s*-shaped curve of the descender and close the bottom loop. Finally, make a short horizontal stroke attached to the right side of the first stroke. This part of the letter is the "ear."

The alternate ways of writing *b* and *d* provide a bit of a shortcut by eliminating one or more of the strokes found in the earlier versions. It is good to have a range of styles from which to choose, to impart lively variation to your writing. These are just a few of the many alternative forms possible in this versatile hand.

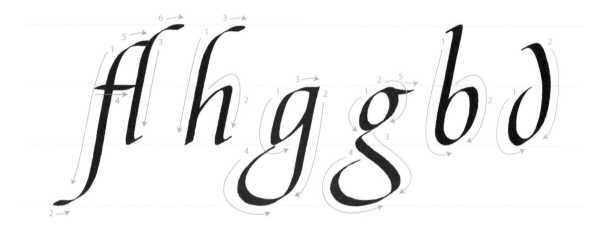

Letter Combinations

After you have gone through all the iterations of the small letters, you will be ready to try letter combinations. A traditional exercise is to write all the letters with the letter *n* between them, as shown in the illustration. This helps to train your eye to see the equidistant spaces between the letters that will give your writing a pleasant rhythm.

From the stroke sequences shown in the examples, you know that careful writing of italic forms requires that you lift the pen and put it down again, taking multiple strokes to create a letter. When written rapidly with few, if any, pen lifts, the letters take on a hurried, less graceful appearance, but are still quite legible and useful as everyday handwriting. The choice is yours how formal you wish to make italic letters, but a beautiful italic requires many pen lifts and a slow, deliberate pace.

anbncndnenfngnhni

4.

~ **CAPITALS** ~

You're now ready to add the capitals (also known as majuscules) to your repertoire. The capital letters have a much longer history than the small letters, and their appearance has changed very little since the first century in Rome. At first glance, the capitals don't seem to have much in common with the small letters, but actually the small letters evolved from the capitals over a period of about fourteen hundred years. When italic emerged during the Renaissance, the capitals were "borrowed" from that much earlier time, and were written with a size of about six to seven pen widths. At that height they did not reach the tops of the ascenders. This may be a bit different from the way you are used to seeing them, but in italic calligraphy they look best lower than the top of the ascenders, to keep them from overwhelming the small letters. There are occasions when you may want the capitals to soar above everything else, but for the majority of the time they will be modest and lower than the tops of the ascenders.

Although you are already acquainted with capital letters, there are details in their construction with a broad-edge pen that may not be familiar to you. Compare your letters with the examples, and take notice of the stroke sequences shown. Make your letters with the same slant and pen angle as the small letters. They will share the same base line, but unlike the small letters, their widths will vary. Since you are already familiar with the pen angle, slant, and serifs of the small letters, you can concentrate more fully on the shapes of the capitals.

The Simplest Capitals

As with the small letters, the first group of letters to practice are the simplest—*E, F, I, J,* and *L*. Note that the horizontal strokes on the *E, F,* and *L* are the same length and short. The *J* has a very short descender to distinguish it from the *I*.

E F I J L

Wider Capitals

The next group of letters also consists of relatively easy straight or diagonal strokes, but the letters in this category are a bit wider than the first group—*A, H, K, N, T, V, X, Y,* and *Z*. Try to make these letters appear to be the same width.

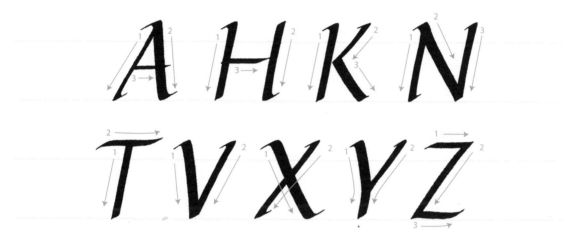

Curved Capitals

The next category will introduce the narrow letters with curves, *B*, *P*, *R*, and *S*; then the wider letters with curves, *C*, *D*, *G*, and *U*; and finally the *O* and *Q*. The last two letters of the model show a comparison of the *M* and the *W*. They are the widest letters of the capitals; note that they are not mirror images of each other. The first and last legs of the *M* are only very slightly splayed, and none of the strokes are parallel. The *W*, on the other hand, consists of two *V*s that are connected, and the first and third strokes and the second and fourth strokes are parallel to each other.

B P R S

C D G U

O Q

M W

Capital and Small Letter Combinations

The capitals are a bit more demanding than the small letters and require patient practice to master, but the results will be well worth the effort. Acquiring a lovely italic hand is a work in progress.

A good exercise for practicing capitals and small letters in combination is to make an alphabetical list of names. It can be names of people, but perhaps a more interesting list can be of mountains (as shown in the illustration), rivers, flora, or fauna. An Internet search will produce many such lists, some down to a specific region or country.

This exercise will touch on layout and the importance of margins. Leave a 1-inch margin on the top and sides of your paper, and make the bottom margin deeper, 1½ inches. This is a classic arrangement of text on a page and creates an elegant frame around your calligraphy. Begin your list and continue as if you were writing normal prose. You won't be able to fit all the words on one page, so simply continue on another page. Between words, leave no more than the space of an *n*. You may find that you like the looks of this so much that you will want to do it again on a larger sheet of better paper so that you can fit all the words on a single sheet. With a little practice it may well turn into a piece worthy of framing, and a great conversation piece.

Alpamayo Bakirtepe
Chogolisa Doughgob
Esjufjöll Fanatkogl
Giakupitsa Haystack
Ilmspitze Jigatake
Kilimanjaro Lahitkaya
Maljovitza Narodnaya
Oppkuven Pferdskopf

5.

~ NUMERALS ~

Finally, there are the numerals. The numerals we refer to as Arabic numerals originated not in the middle East, but in India. After Indian mathematicians discovered the concept of zero, they devised a symbol for it and for digits one through nine. It was Arab traders who brought the new symbols from India to Europe during the eleventh century, dramatically advancing mathematics and account keeping. The symbols were known thereafter as Arabic numerals.

Again, make them top to bottom, left to right, using the same pen angle and slant as the letters. You will notice that some of them have a bit of an ascender, and some a bit of a descender, but usually no more than one or two pen widths. This feature makes them blend in beautifully with your italic, which also consists of a variety of ascending and descending letters.

You will most likely use numerals to denote time, date, or address. It is worth noting that postal workers sometimes fail to recognize calligraphically written numerals, so make them as clearly as you can, and avoid any unnecessary flourishes when addressing envelopes.

1 2 3 4 5

6 7 8 9 0

Put It All Together

The next exercise will give you practice writing capitals, small letters, punctuation, and numerals. First, write a short letter to someone, remembering to allow margins. While notebook paper might not be your preferred paper choice, you will be forgiven while you are learning, and the recipient of your letter will be flattered and appreciative.

In the example shown, the ascender and descender spaces are reduced by two pen widths. The guidelines are included so you can see how everything now fits on the lined notebook paper. Tight interline spacing is also dealt with by leaving off a nonessential part of the letter. The descender of the y in the first line nearly collides with the C underneath it, but by leaving off the end stroke of the descender, the two letters coexist quite happily.

Richard Tracy
32 Clueless Court
Findem, California
95460

Create an Undersheet

Of course, you won't want the guidelines to show on your envelope, nor do you want the bother of erasing them. An easy way to "see" the guidelines without having to draw them on the envelope is to take a blank sheet of notebook paper and darken enough of the lines with a ballpoint pen to accommodate the lines of the address. You will need to allow for ascenders, body, and descenders for at least three lines. Cut this whole group of lines to the size of your envelope and insert inside so the guidelines face the address side of the envelope. You should be able to see the guidelines well enough through the face of the envelope to write the address. When you're done, remove the guidelines and insert your letter. No erasing of guidelines is necessary! This is a useful trick to remember when you have many envelopes to address. Affix an attractive stamp and mail it off to a grateful recipient.

This method of creating an undersheet works for many lightweight papers. An even easier method is to use online sources that generate guidelines for you for free. Do a search for "calligraphy guidelines," choose any one of several that come up, and simply type in the values for ascenders, body, and descenders. Your undersheet will be limited by whatever size your printer can handle, but this service is a great and accurate time-saver and allows you to expand your paper choices.

6.

~ FLOURISHES ~

A natural springboard to flourishing can be found in your normal handwriting. You may have incorporated several flourishes into your writing over the years without being too aware of it. Take a look and you may find a few that you might like to try with the broad-edge pen. It's that simple. To begin, be mindful that a flourish should not obscure any part of a letter, and it will usually be an extension of an existing part of a letter.

You have already been introduced to alternate forms of letters with curved ascenders and descenders. Flourishes are simply composed of those same curves, only expanded. Take an otherwise simple letter, such as an *l*, to practice extending the top of the ascender into a generous curve. You will be adding both height and volume. As with all of your letters, assume the same slant and pen angle, and begin your flourish where the pen makes the thinnest mark. Think of tracing around a large oval or ball when making your flourish. The example shows a gray oval behind the stroke to give you an idea of the size and shape you should aim for. The *y* shows how the same oval can be applied to a descender. The more "air" you introduce into your flourish, the more impressive it will be. Other simple extensions of the small letters are also shown to give you some idea about how and where to extend. These can be quite large and exuberant, depending on your mood.

There are a few standard ways of adding flourishes to capital letters. In the illustration, note how the flourishes on the capital *H* are constructed. First, add a horizontal extension to the top of the left stem. Then add another

flourish to the upright stroke on the right stem. Many italic capitals are frequently seen with at least one of these standard flourishes. When adding these curves, just as with the small letters, imagine tracing around a large circle or oval. Give them plenty of room. Flourishes should not be inhibited by too small a space.

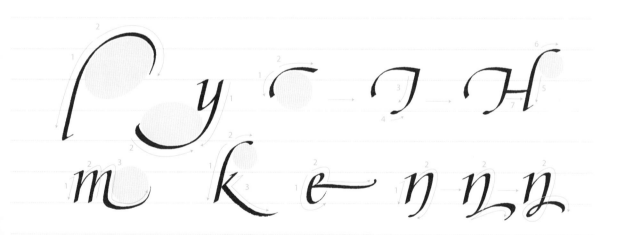

You will achieve the most graceful curves by putting your whole arm into the effort. Trying to do them with finger movements alone will yield less than satisfactory results. After mastering simple arcs, you can attempt more complex designs, but don't try to do them until you are confident in your simple arcs. Inventiveness plays a huge role in fashioning flourishes. Hours have been known to disappear when practicing or exploring ways to embellish your calligraphy. Often it is helpful to sketch out your plans for a flourish with a pencil on paper to get some idea of shape, placement, and balance.

Calligraphy

Flourishes in Action

The next exercise will give you practice with flourishes, capitals, small letters, and numerals. At times you will want your writing to look a bit freer, more casual than your formal italic. One way to achieve this look is by writing without guidelines. Your writing will naturally hover between the unseen guidelines, much as your normal handwriting does. You probably haven't written with guidelines for many years, yet most likely you can write in a uniform size and in reasonably straight lines when you're trying. The same will be true with your italic, though you won't be able to write it as fluidly as your normal handwriting for some time. Do warm up first with freely written squiggles, shapes, or letters.

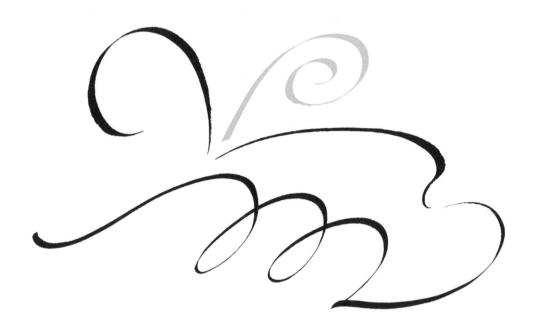

Try just a word or two at first. Our lives are busy, and we don't always have the time to write a letter to someone, but sometimes we need to jot a few lines of thanks or congratulations. It's not difficult to create a card incorporating a relaxed but flourished italic and a handwritten message. Stationery, art, and paper stores sell many matching papers and envelopes. Select a paper that is blank and folded in half. On the outside, write "Thanks" or "Congratulations" or "Happy Birthday" in your best informal italic. Employ an exuberant flourish or two. The card can be further embellished with a few doodles, rubber stamps, or other simple designs, but calligraphy is its own best ornament. You may even like the face of your card well enough to want to reproduce it for future use. Your local copy shop or an online printing service can provide multiple copies at a very reasonable cost.

Inside your card, write a few lines in an ordinary ballpoint, using your best italic, of course, but at a smaller size, more like that of your regular handwriting. Address your envelope using the technique described earlier. These simple pieces fulfill your social obligations as well as provide you with practice on real projects.

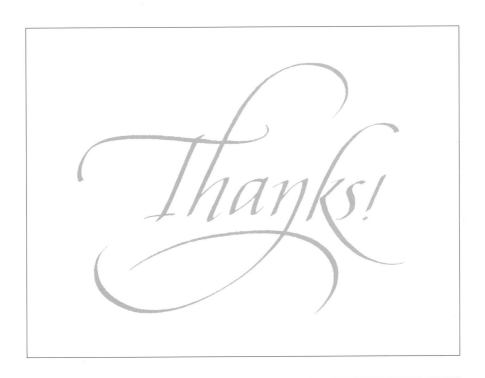

Dear Alan. 30 · VIII

I am so grateful for the book you sent.
The exquisite handwriting samples (and
translations) are just what I've been
looking for. I will savor this gem for
a long time to come. Thank you
for your thoughtfulness.

Love,
Judy

7.

∼ PROJECT IDEAS ∼

There are countless ways to use your newfound calligraphy skills, from invitations to menus to programs. When writing your final versions, be sure to include the date and name of the event, for these pieces make wonderful keepsakes and scrapbook items. They will take some planning and a few trial runs to discover how much space they will occupy on the paper you've chosen, how the ink behaves on the paper, which colors look best, and which arrangement of text is the most pleasing.

Arrangement of text, or layout, is an important aspect of calligraphy, and a few pencil sketches of various ideas will help to solidify how you'd like the final piece to look. Do you like a centered arrangement, or is flush left better? Perhaps you'll use a combination of both. It's like trying on a few outfits to see which you like best. You will need to decide how much space to allot between the lines of writing, and allow for margins. Let's say you've decided to center your lines of writing, such as shown in the menu illustration. This centered arrangement is commonly found in menus, announcements, and invitations. You'll notice that the writing is all the same size, but the ascenders and descenders are shortened, and the interline spacing varies. Standard forms are used along with alternates, numerals, and flourishes, including a decorative ornament. You can take the guesswork out of centering by writing out your lines first on a separate piece of paper. Then cut out each line close to the base line and tape with low-tack tape to your final paper in the centered position directly above where you want to write. Then you can copy the line letter by letter and match your spacing. Repeat for each succeeding line to get a nicely centered arrangement.

Dinner
in honor of
Marie de Rabutin-Chantal
marquise de Sévigné

Soupe à l'Oignon
Poulet au Citron
Haricots Verts
Salade d'Epinards
Madeleines
Champagne

5 February 2016

Ornaments

Ornaments provide a charming decorative element to your calligraphy and are fun to invent. Begin by making the geometric shapes first. This will give you good practice on maintaining a consistent pen angle. These kinds of ornaments can be used singly or in a row to create a compatible border for your calligraphy. Just about any pen stroke or pattern can become a potential ornament. Simple pen strokes become botanical motifs, and wave patterns emerge easily.

The more difficult ornamental designs or arabesques are built around the ovals you practiced earlier when learning basic flourishes. Reversing curves are the backbone of arabesque ornamentation. Thick lines going in one direction become thin lines when the curve is reversed. The only rule for dealing with arabesques is to make sure a thick line never crosses a thick line. Remember: Thin lines crossing thick lines keeps you out of trouble. Enjoy this little diversion, but don't rely on ornamentation to rescue poor letterforms.

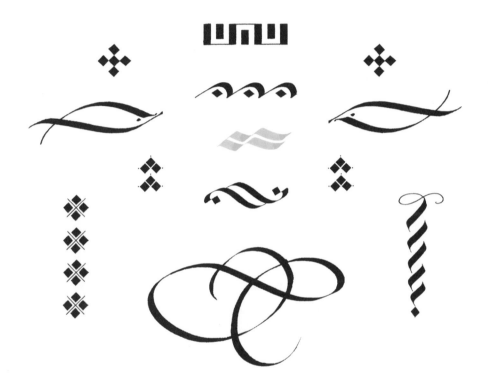

Place Cards

Any special occasion dinner is made more festive by creating place cards for the table. They can be done as formally or informally as the occasion warrants. At a very formal dinner, use both first and last names on the place card. Usually the best arrangement is to stack the names one atop the other. More informal occasions will call for just a first name. The simplest kind of place card to make is the standard tent type, made from folded card stock. The width of the place card will be determined by the length of the longest name. Write that name out and trim to the size you think looks best, then make all the other cards that size.

Let's assume that you'd like the names to be centered on the place cards. The easiest way to do that is to write the names on a sheet of card stock with ample margins around each. On a separate piece of card stock, cut out a window that is the full size of the card unfolded. This will be your master to use to transfer small corner marks onto your place card stock. Place the window on top of the name you have written, and move it around until everything is to your liking. Transfer some small corner marks. Then, using a steel ruler aligned with the corner marks, trim your cards with a craft knife drawn against the ruler.

An informal occasion is perfect for trying out a few flourishes combined with a decorative ornament. Don't be too elaborate in flourishing and decorating; just add enough to reflect the theme or colors of the party.

Invitations

One of the most popular uses of italic calligraphy is for wedding invitations or announcements. Unless you are planning to write only a few invitations, you will probably want to make a master design and have them printed from that. You should consult with your printer before writing the invitations to make sure your design will be the proper size and proportion.

Traditionally, the names of both bride and groom are written in a larger size than the rest of the text. This is the time when you might consider buying another size pen, either larger or smaller than the one you've been using so far. Your design options multiply dramatically when you have two sizes to work with. If you don't feel ready for that, there are other options open to you. You can use a typeface for everything but the names on the invitation. Your printer can follow a traditional format to create the invitations, leaving a blank area for you to add the names of the bride and groom in calligraphy, or your calligraphy can be incorporated into the typeset design. Another option is to use type for the entire invitation including the names, and then use a calligraphic monogram of the bride and groom's initials as a decorative element. Again, your printer can incorporate the monogram into the type-written text, or you can write it on each invitation by hand. The example shown uses calligraphy for the names of bride and groom and features the rest of the invitation set in type, in this case Bodoni, a classic typeface in continual use since its creation in the eighteenth century. Keep any typeface you use relatively simple. You don't want your calligraphy competing with your typeface.

Rebecca and George Long
request the honor of your presence
at the marraige of their daughter

son of Rebecca and Henry Dykes
Saturday, the nineteenth day of April
twenty sixteen
at two o'clock in the afternoon

at the Long Home • Longs Bend, Tennessee

8.

~ **ADDITIONAL ALPHABETS** ~

Just as there are advantages to learning alternate forms of italic letters, there are also advantages to learning other alphabet styles along with italic. Each of the alphabets shown are deeply rooted in history, yet they are timeless in their appeal. Each has a "personality" that can help convey the meaning of your words, and each mixes well with italic on a page. Although specific directions for making these alphabets are not included here, you should be able to figure a few things out by reverse engineering—determining the slant (if any), the pen angle, and the proportion by finding a pen nib that matches the width of the widest stroke, and tracing the letters.

The first alphabet shown is called Uncial. An all-capital alphabet, Uncial was in use during the so-called Dark Ages from approximately the fifth through the ninth centuries. Updated for use in the twenty-first century, this very popular alphabet stands alone or blends well with other styles such as italic. The forms are identified by their mostly rounded shapes and are relatively easy to learn.

The other alphabet shown in this section, Fraktur, consists of both small letters and capitals. Since its appearance in the early sixteenth century, this beautiful alphabet has been in continuous use for everything from manifestos to packaging to tattoos. It is wonderfully capable of expressing many moods. Fraktur evolved slowly over hundreds of years from earlier Latin letterforms. Indeed, the capital letters can be traced to the much earlier Uncial forms mentioned above. Whether used to create elegant, bold, or daring text, it makes a strong impression.

Uncial

ABCDEFGh
IJKLMNOP
QRSTUVW
XYZ

Fraktur: Small Letters

abcdefghij

klmnopqr

stuvwxyz

ABCDEF

GHIJKLM

NOPQR

STUVW

XYZ

∾ FURTHER STUDIES AND RESOURCES ∾

To expand your skills and knowledge of calligraphy—from learning to write with dip pens to exploring other nibs, papers, inks, paints, and letterforms—do look for classes in your area. Besides learning additional skills and alphabets, a class in calligraphy provides invaluable personal assistance and the camaraderie of like-minded classmates. A natural extension of classroom camaraderie is found in the many calligraphy guilds and societies scattered across the world whose purpose is to promote the study and practice of calligraphy. You can find a current list of US and Canadian guilds at

✑ **www.friendsofcalligraphy.org/pages/resources.html**

Although art stores may carry a few calligraphy supplies, many hard-to-find items can be obtained only from vendors who specialize in calligraphy supplies. There are two in the United States that sell all the calligraphy tools and materials anyone could want, and both are helpful in answering questions and offering suggestions. Both are online and issue print catalogs as well:

✑ **John Neal Bookseller • 800-369-9598 • www.johnnealbooks.com**
✑ **Paper & Ink Arts • 800-736-7772 • www.paperinkarts.com**

Many libraries in major metropolitan areas house calligraphy collections—both historical and modern—which are instructive and inspirational. If you are ever in the San Francisco Bay Area, visit the San Francisco Public Library; it contains one of the largest and best contemporary calligraphy collections in the United States: the Richard Harrison Collection of Calligraphy and Lettering in the Book Arts and Special Collections Center. Your study of calligraphy will also benefit from visiting art museums and galleries to learn from the creativity and ingenuity of other artists.

Any written communication can be rendered in calligraphy to great effect, and on almost any surface—paper, wood, stone, glass, metal, and beyond. The more you write, the more you will find that calligraphy goes beyond merely words made with beautiful writing. The craftsmanship involved closely allies it with great art. There is a lifetime of avenues to investigate. *Vive la plume!*

∾ ABOUT THE AUTHOR ∾

JUDY DETRICK is a calligrapher and designer living on the Mendocino coast of Northern California. She taught calligraphy and graphic design at College of the Redwoods on the Mendocino coast for more than twenty-five years and developed the Graphic Arts Certificate Program there. Her work can be found in several anthologies of calligraphy and graphic design, and she is represented in the Richard Harrison Collection of Calligraphy and Lettering at the San Francisco Public Library. She served as editor of *Alphabet, the Journal of the Friends of Calligraphy* from 2007 to 2010. A parallel interest of hers is letterpress printing, and under the imprint of the Attic Press she has produced several limited edition books and a wide collection of ephemera. She teaches regularly at the San Francisco Center for the Book, for the Friends of Calligraphy, and at other venues throughout California.

∼ ACKNOWLEDGMENTS ∼

I am deeply indebted to all the calligraphers over time who have written books like this one to help carry on the tradition. I'm also grateful to the teachers who have inspired me and to my students who have taught me everything I know about how to give instruction in calligraphy. Thank you to my editor Lisa Westmoreland, who proposed the idea for this book at the outset, and to designer Tatiana Pavlova and the rest of the great folks at Ten Speed Press for making me look good; to Susie Taylor, Linnea Lundquist, Linda Turner, Adrienne Ardito, and Kate Dougherty, who provided invaluable criticisms, suggestions, and support throughout; and above all, to my patient family, without whom there would be nothing.

～ INDEX ～